THE NEW YORKER HATES MY CARTOONS

KYLE OWENS

Introduction

I always wanted to be a syndicated newspaper cartoonist since High School when I found a book at the public library entitled "How to be a Cartoonist." Before I even opened the book I knew cartooning was my destiny.

I concentrated on newspaper strips of various characters that I created hoping to find my place on the comics' page. However, my destiny took a turn for the worse with the collapse of the newspaper industry when it was obvious that new comic features weren't a top priority of syndicates or newspapers anymore. Now they simply ran reruns of old strips or if a creator died they'd have a family member take over or the syndicate would hire a new creative team to continue the strip.

So I wondered how I could continue my love for cartooning. That answer came to me one Christmas by way of a book entitled "How About Never- Is Never Good For you?" by The New Yorker cartoon editor, Bob Mankoff.

I had submitted cartoons to The New Yorker before,

along with a few other magazines, but because I wanted to be a comic strip artist these submissions would be best defined as token efforts.

But Mankoff said that in 1990 he sold 34 cartoons to The New Yorker alone and made about 30 thousand dollars. That made my head explode and the token effort of my past became an obsession to join the ranks of the contract cartoonists at The New Yorker.

So I sent a batch of cartoons in almost every month beginning in 2014. Mankoff recommended sending 10 cartoons per batch, but I would send only 5 because it was less devastating to have 5 rejected than 10.

But despite my excitement and energy, nothing was happening. All I would get were form letter rejections. So I wasn't sure if I was getting close or was so far off that my submissions were considered the office joke.

To help my chances I bought several books on The New Yorker cartoons and quickly learned that it took several cartoonists up to two years to simply have their first cartoon accepted for publication. This gave me some hope in the fact that I wasn't the only one that had been enduring this process of constant rejection.

But then I did my two years and still nothing was accepted. I got another book entitled, "The Rejection Collection," which consisted of rejected cartoons from The New Yorker contract cartoonists. In the introduction it said, "In each issue of The New Yorker, there's only room for something like fifteen to twenty cartoons, and there are around fifty regularly contributing cartoonists, who each bring in ten cartoons every week. That's five hundred right there. And that's not counting the slush pile, which, if you don't know, is the colossal scrap heap of cartoons that come in from all over the world from unknown hope-

fuls, whose chances of being discovered are slim to none. (Nothing personal, I'm just telling you how it is.)"

I closed the book and sat in the dark realizing with the deepest devastation that the one thing I wanted to do more than anything else in the world was not only closed off to me, but that maybe I just wasn't any good at it.

The next day I was watching TV and the phrase "The New Yorker Hates my Cartoons," popped into my head. Hey, that would make a great book title, I thought to myself. So with renewed cartoon vigor I sent off a bunch of emails to publishers that accepted art books.

Not one of them replied.

It was obvious that I could change the title of my book to, "Everybody Hates my Cartoons."

So I decided to give up on cartooning for a bit and concentrate on selling short stories and novels. My writing had given me very limited success, but it was 100 percent better than how my cartoons were doing.

I ran upon CLASH Books in the Manuscript Wish List twitter feed when I was searching for agents and publishers looking for books. So I thought I'd just email them and see what they thought about my cartoon book idea.

And they actually responded.

Not only did they respond they were interested in the idea, they also asked me to send over the cartoons for them to look at.

Stunned beyond belief, I sent in the cartoons and they actually liked them. They sent me a contract and I finally was able to shout to the world that I'm a cartoonist!

Now I know what you're asking yourself right now.

Will he continue sending in cartoons to The New Yorker? The answer is absolutely.

It's become a thing on my bucket list to have one of my cartoons in The New Yorker before I die. Now I have to admit that so far death is winning, but I'm going to keep trying.

If you're also trying to sell a cartoon to The New Yorker I say keep going at it. Hopefully you'll achieve your dream quicker than I will mine, but hey, if they don't buy any of your cartoons- you can always put 'em in a book.

Draw on!

Kyle Owens

2019

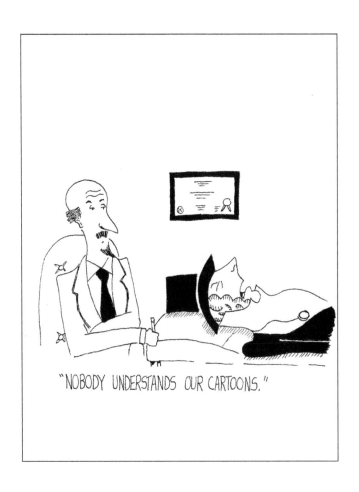

"NOBODY UNDERSTANDS OUR CARTOONS."

SUDDENLY-THREE DAYS INTO THE TRIAL, ED
REALIZED HE DID IT

A VOICE KEPT HAUNTING KOZAR THE CAVEMAN—
"BUILD IT AND THEY WILL GO."

"FOR CRYING OUT LOUD FRANK - THE ROAST WAS FOR EVERYBODY!"

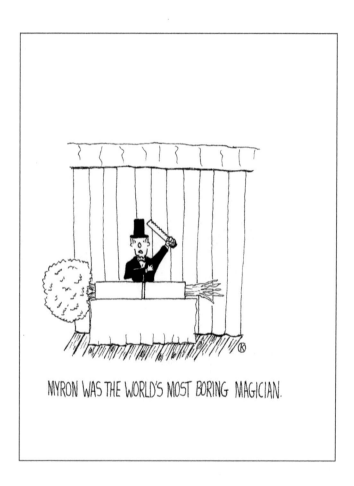

MYRON WAS THE WORLD'S MOST BORING MAGICIAN.

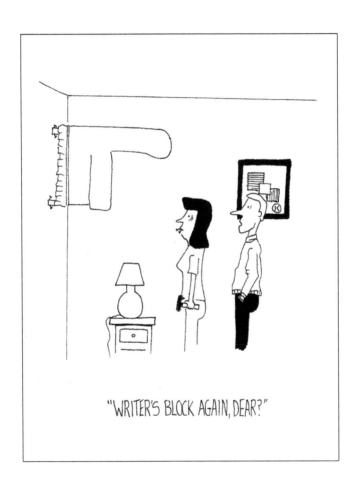

"WRITER'S BLOCK AGAIN, DEAR?"

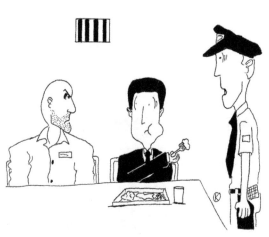

"UH-THE LAST MEAL WAS FOR YOUR CLIENT."

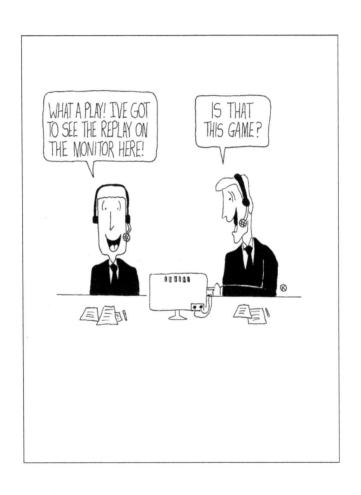

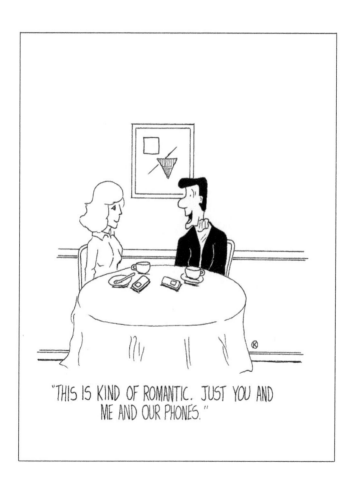

"THIS IS KIND OF ROMANTIC. JUST YOU AND ME AND OUR PHONES."

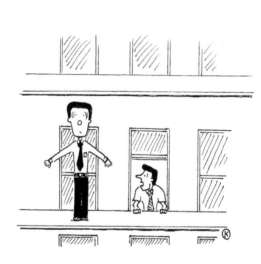

"BEFORE YOU GO WHAT'S THE PASSWORD FOR THE HENDERSON FILE?"

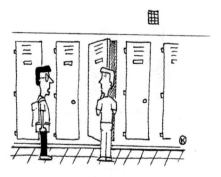

"I CAN'T COME OVER THIS EVENING. I HAVE TO DO A BOOK REPORT ABOUT SOME WOMAN NAMED PEARL HARBOR."

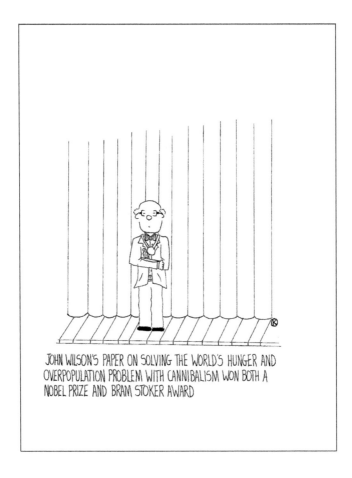

JOHN WILSON'S PAPER ON SOLVING THE WORLD'S HUNGER AND OVERPOPULATION PROBLEM WITH CANNIBALISM WON BOTH A NOBEL PRIZE AND BRAM STOKER AWARD

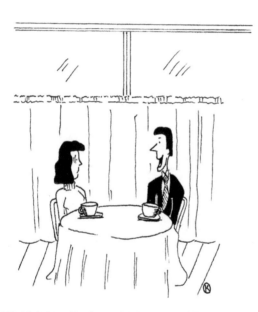

"I'M GREAT WITH KIDS. WOMEN ARE ALWAYS CALLING ME CHILDISH."

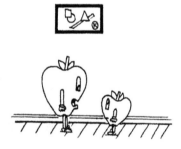

"I'M PROUD OF YOU FOR GETTING A JOB, BUT I DON'T BELIEVE YOU FULLY UNDERSTAND WHAT BEING A FOOD SAMPLE IS."

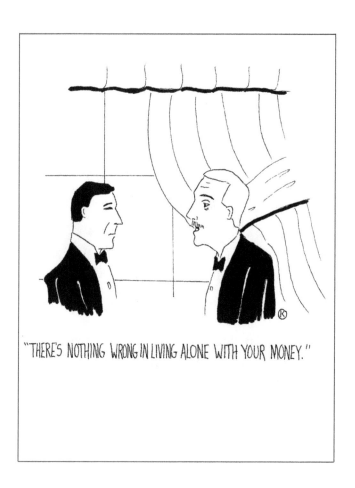

"THERE'S NOTHING WRONG IN LIVING ALONE WITH YOUR MONEY."

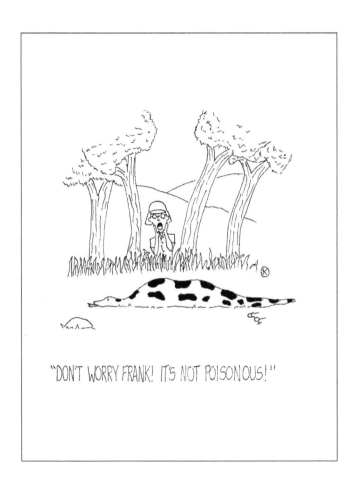

"DON'T WORRY FRANK! IT'S NOT POISONOUS!"

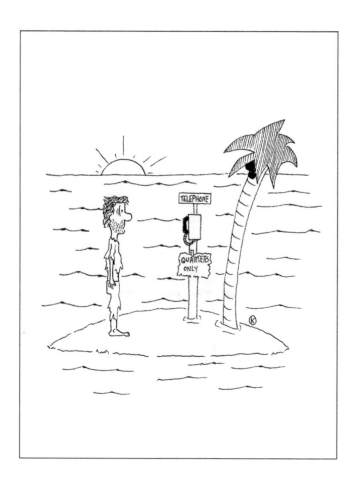

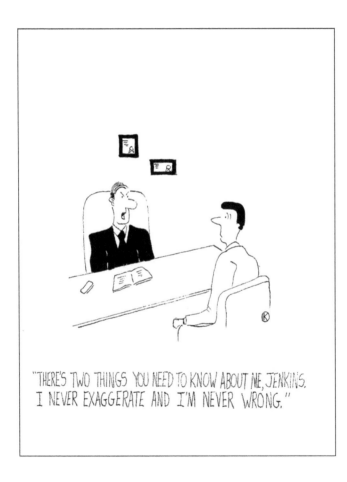

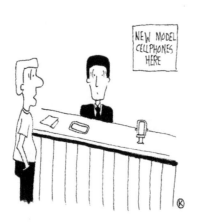

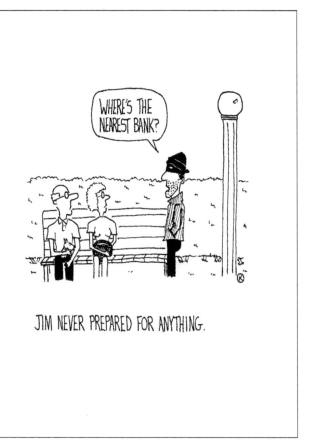

"THAT'S NOT WHAT I MEANT WHEN I TOLD YOU TO BRING HIM BACK."

"I'M GOING TO TRY AND GET A GRANT FROM THE MOM AND DAD FOUNDATION."

"I PLAYED THE PIANO IN THE MARCHING BAND. I WAS THE ONE WITH THE BAD BACK."

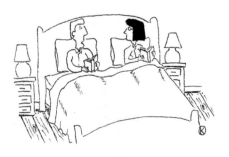

"IF YOU WERE ON A DESERT ISLAND WITH JAMES JOYCE
AND PICASSO WHO WOULD YOU DROWN FIRST?"

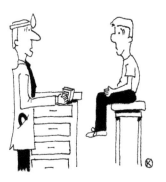

"THESE SLEEPING PILLS ARE NON HABIT FORMING. THERE'S ONLY ONE IN THE BOX."

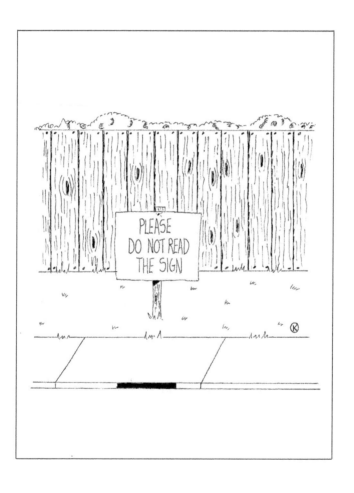

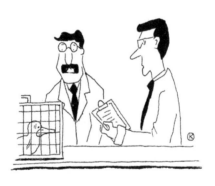

"WELL, IF IT WALKS LIKE A DUCK AND QUACKS LIKE A DUCK THEN IT'S PROBABLY A CLONE."

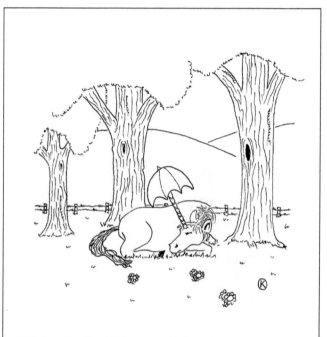

AND ALL OF THE OTHER UNICORNS, USED TO LAUGH AND CALLED HIM NAMES — AND THEN IT RAINED.

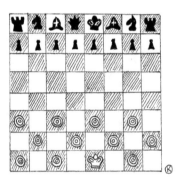

KING WHITE'S CHECKERED PAST FINALLY REVEALED
ITSELF.

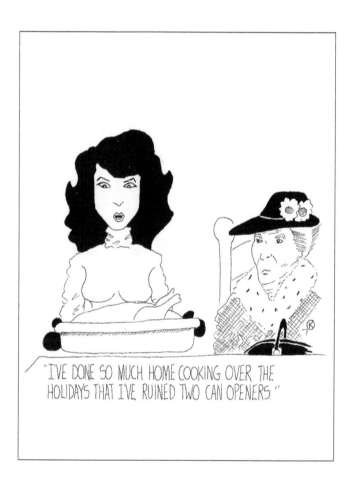

"I'VE DONE SO MUCH HOME COOKING OVER THE HOLIDAYS THAT I'VE RUINED TWO CAN OPENERS."

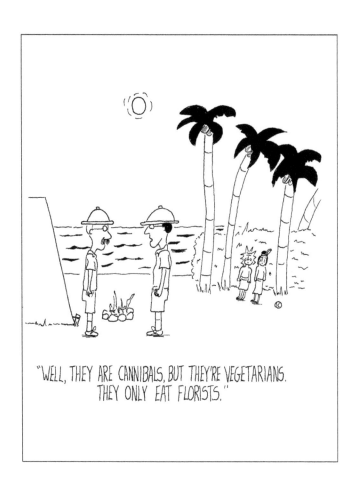

"WELL, THEY ARE CANNIBALS, BUT THEY'RE VEGETARIANS.
THEY ONLY EAT FLORISTS."

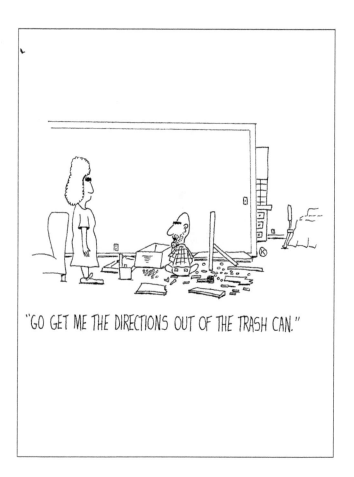

"GO GET ME THE DIRECTIONS OUT OF THE TRASH CAN."

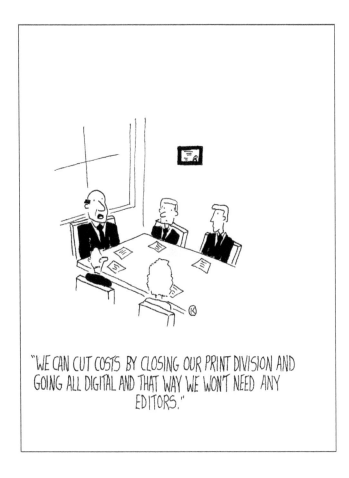

"WE CAN CUT COSTS BY CLOSING OUR PRINT DIVISION AND GOING ALL DIGITAL AND THAT WAY WE WON'T NEED ANY EDITORS."

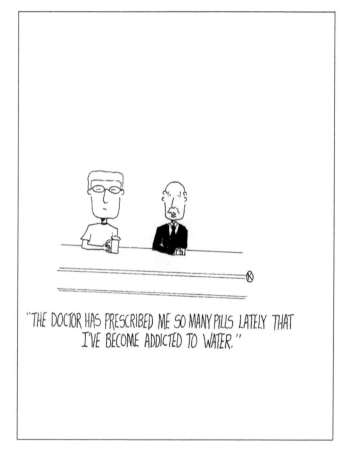

"THE DOCTOR HAS PRESCRIBED ME SO MANY PILLS LATELY THAT I'VE BECOME ADDICTED TO WATER."

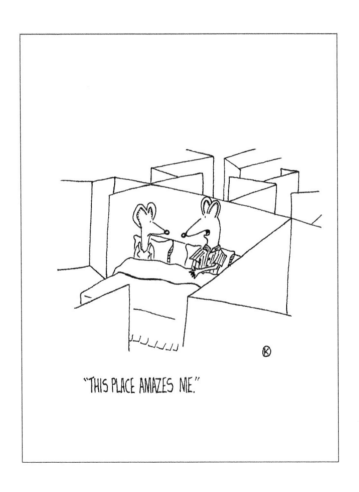

"THIS PLACE AMAZES ME."

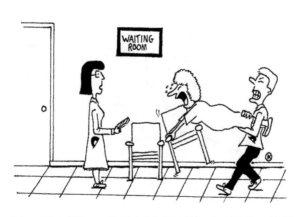

"OKAY MRS. JENKINS, YOU WIN. WE WON'T CHECK YOUR WEIGHT THIS TIME."

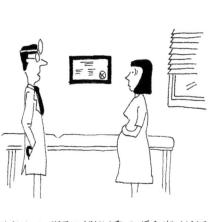

"THE ONLY ADVICE THAT I KNOW TO GIVE A NEW MOTHER IS TO STOP AT ONE."

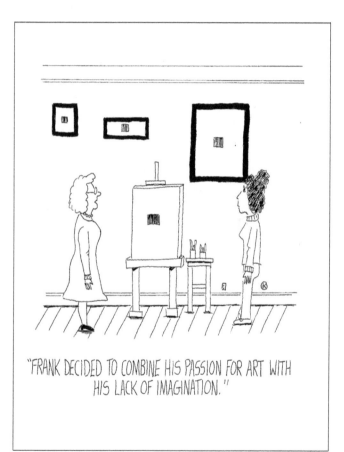

"FRANK DECIDED TO COMBINE HIS PASSION FOR ART WITH HIS LACK OF IMAGINATION."

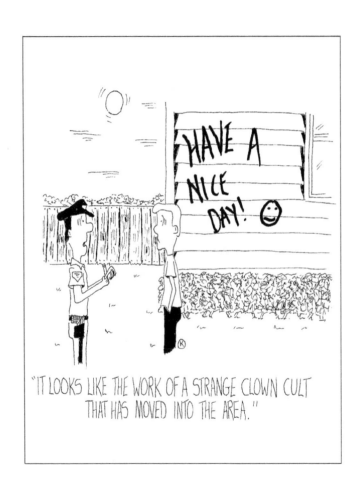

"IT LOOKS LIKE THE WORK OF A STRANGE CLOWN CULT
THAT HAS MOVED INTO THE AREA."

WHY CHICKEN FIGHTING NEVER CAUGHT ON IN POLAND.

"FRANK TOOK ME TO A VERY UPSCALE RESTAURANT LAST WEEK.
THEIR DRIVE-THRU WINDOW WAS ON THE SECOND FLOOR."

"IS EVERYBODY OUT OF THE VEHICLE NOW?"

"—BUT I DO RESPECT WOMEN. ESPECIALLY THE ATTRACTIVE ONES."

"UNDER THE LAW YOU ARE CONSIDERED INNOCENT UNTIL ANY FOOTAGE OF THIS ARREST APPEARS ON TELEVISION."

"WOULD YOU ALL CASH A BOUNCED CHECK?"

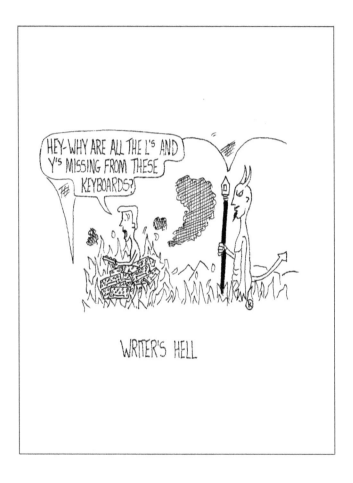

WRITER'S HELL

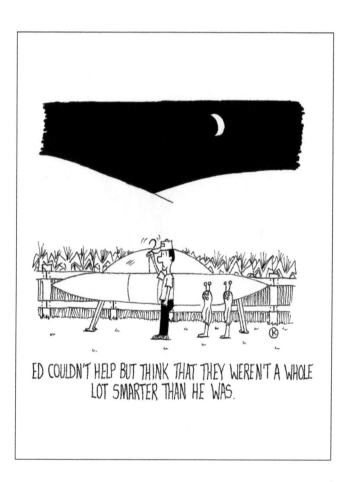

ED COULDN'T HELP BUT THINK THAT THEY WEREN'T A WHOLE
LOT SMARTER THAN HE WAS.

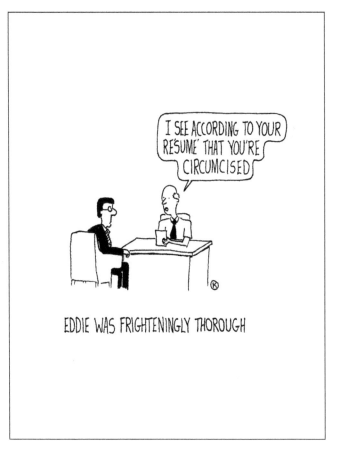

EDDIE WAS FRIGHTENINGLY THOROUGH

"-AND IF ANYONE HAS ANY OBJECTIONS WHY THESE TWO
SHOULD NOT BE JOINED IN HOLY MATRIMONY, SPEAK NOW
OR FOREVER HOLD YOUR PEACE. WHY DON'T I GO FIRST?"

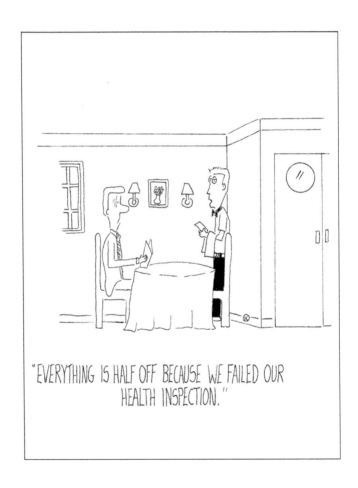

"EVERYTHING IS HALF OFF BECAUSE WE FAILED OUR HEALTH INSPECTION."

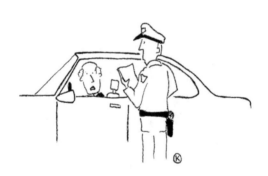

"I'M SORRY THAT I WAS SPEEDING, OFFICER, BUT I'M
A LAWYER AND I'M NEEDED IN A CARTOON."

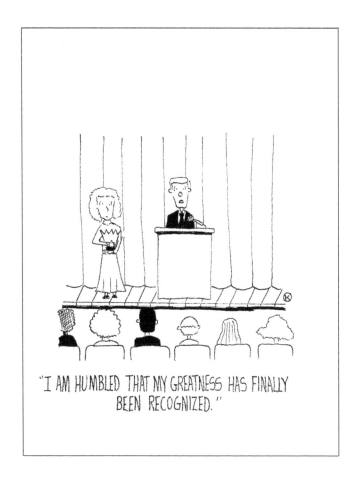

"I AM HUMBLED THAT MY GREATNESS HAS FINALLY BEEN RECOGNIZED."

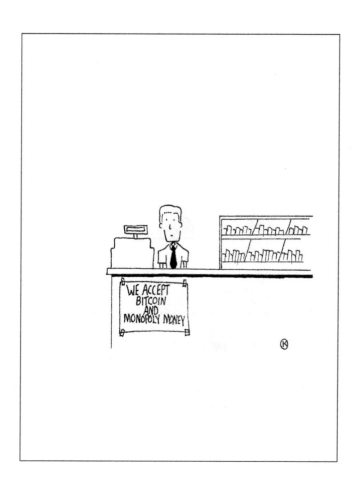

"DAD, WILL YOU CHECK AND MAKE SURE THERE'S NO MATH PROBLEMS UNDER MY BED?"

"OH THAT- I'M BUILDING A PIANO."

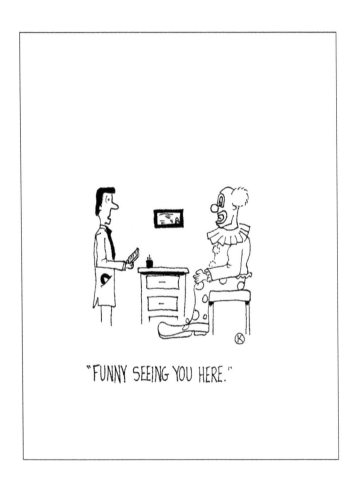

"FUNNY SEEING YOU HERE."

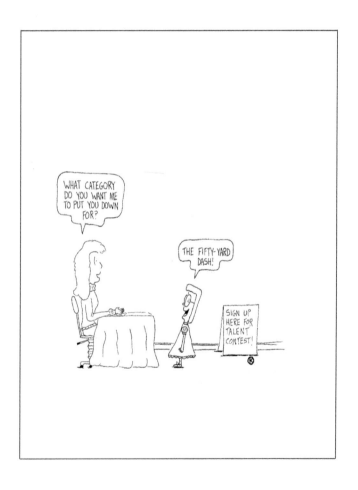

"WOULD YOU TAKE THESE CANADIAN PENNIES TOO?
NOBODY ELSE WANTS THEM."

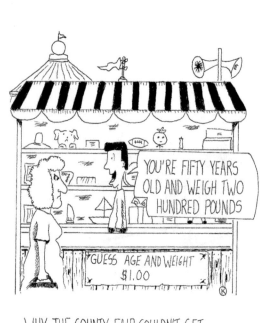

WHY THE COUNTY FAIR COULDN'T GET
INSURANCE

THE FACTS OF LIFE

"MOM, DAD FUNS TOO HARD."

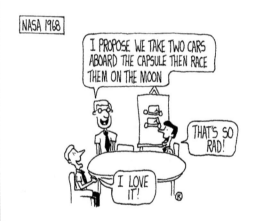

AFTER THIS SUGGESTION NASA DECIDED TO ADD WOMEN TO THE MOON LANDING PLANNING TEAM.

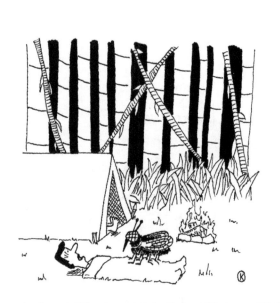

"ED. ED. FLYSWATTER-FLYSWATTER-FLYSWATTER-FLYSWATTER!"

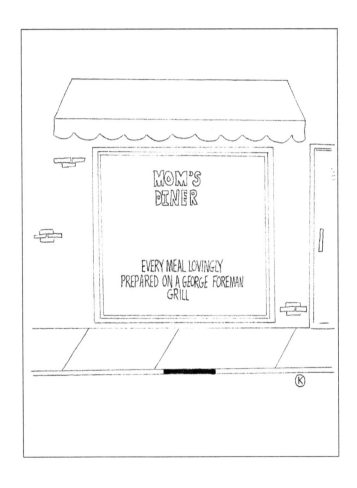

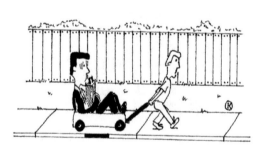

STAN COULDN'T HELP BUT THINK THAT UBER NEEDED
TO BE MORE PICKY

NOAH'S FAITH WAS COMPLETE - TO A POINT

"MY WIFE HAS ME WRAPPED AROUND HER MIDDLE
FINGER."

"I WANT TO THANK BOTH OF YOU FOR COMING TO THE PTA MEETING TONIGHT. AFTER OUR TALK I BELIEVE I KNOW WHO TO BLAME NOW."

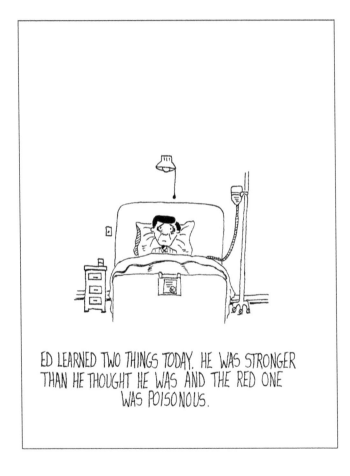

ED LEARNED TWO THINGS TODAY. HE WAS STRONGER
THAN HE THOUGHT HE WAS AND THE RED ONE
WAS POISONOUS.

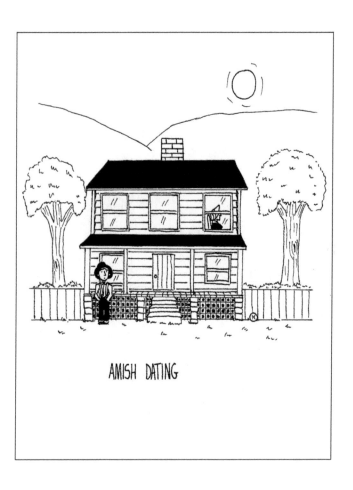

AMISH DATING

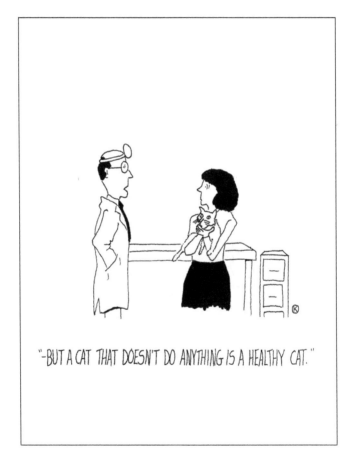

"-BUT A CAT THAT DOESN'T DO ANYTHING *IS* A HEALTHY CAT."

"SIR, IT LOOKS LIKE YOU'RE THE VICTIM OF AN
IDENTITY THIEF"

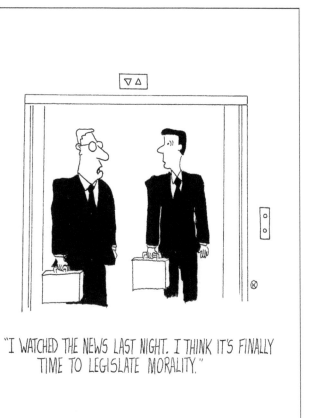

"I WATCHED THE NEWS LAST NIGHT. I THINK IT'S FINALLY TIME TO LEGISLATE MORALITY."

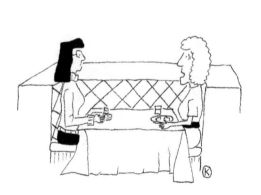

"MY HUSBAND WAS IN THE INFANTRY FOR FORTY YEARS.
THAT MAN COULD DIG A HOLE."

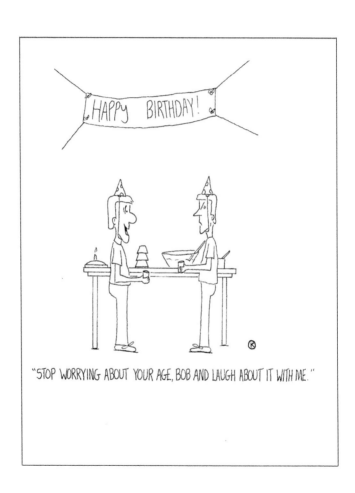

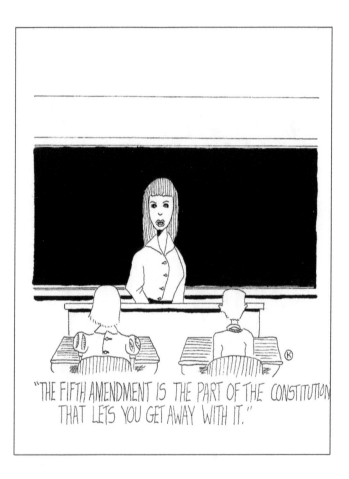

"THE FIFTH AMENDMENT IS THE PART OF THE CONSTITUTION THAT LETS YOU GET AWAY WITH IT."

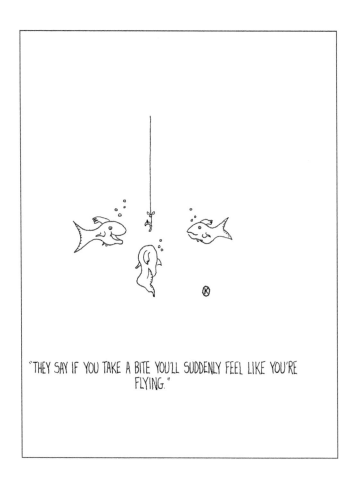

"THEY SAY IF YOU TAKE A BITE YOU'LL SUDDENLY FEEL LIKE YOU'RE FLYING."

"THANKS, DAD. YOU'D BE A GOOD EMOTIONAL SUPPORT DOG."

"WOMEN ARE MORE ASSERTIVE AND OPINIONATED TODAY. IT'S LIKE THEY'VE BECOME THE MEN THEY HATE."

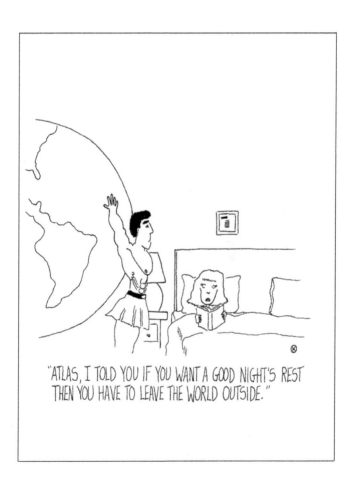

"ATLAS, I TOLD YOU IF YOU WANT A GOOD NIGHT'S REST
THEN YOU HAVE TO LEAVE THE WORLD OUTSIDE."

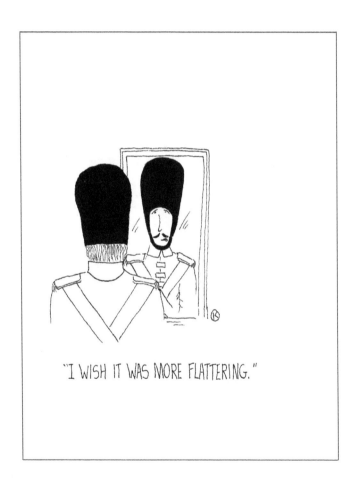

"I WISH IT WAS MORE FLATTERING."

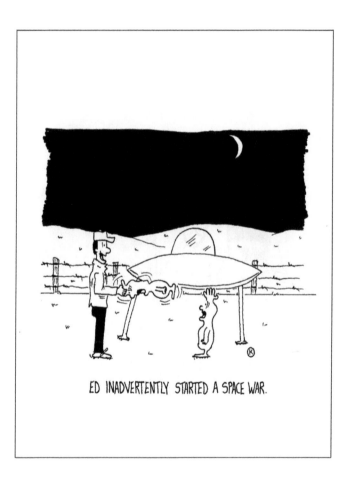

ED INADVERTENTLY STARTED A SPACE WAR.

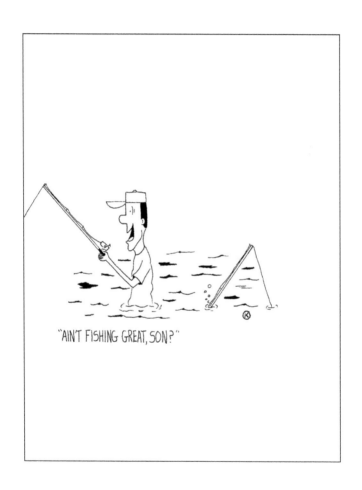

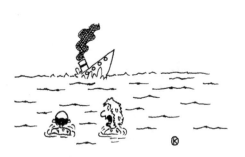

"WELL, WE'RE AWAY FROM IT ALL NOW STANLEY!"

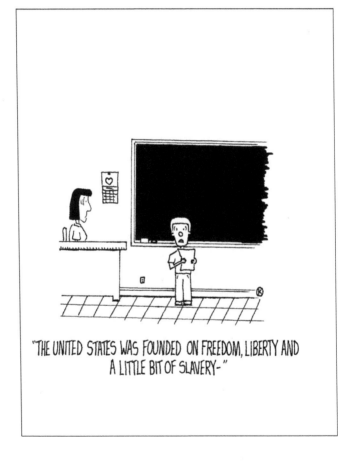

"THE UNITED STATES WAS FOUNDED ON FREEDOM, LIBERTY AND
A LITTLE BIT OF SLAVERY–"

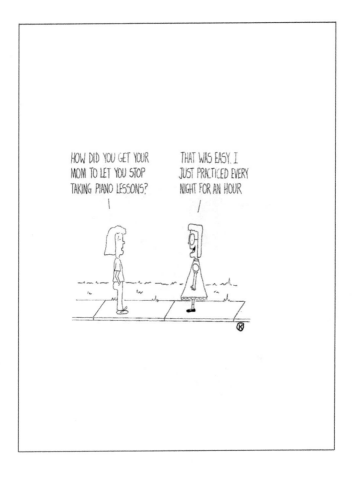

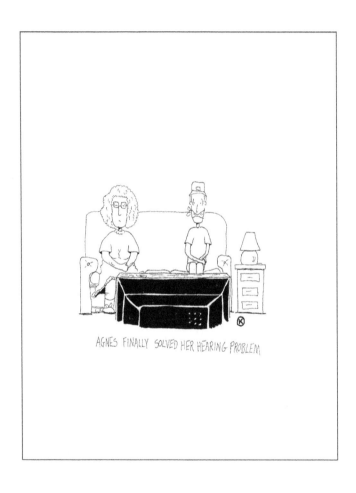

AGNES FINALLY SOLVED HER HEARING PROBLEM

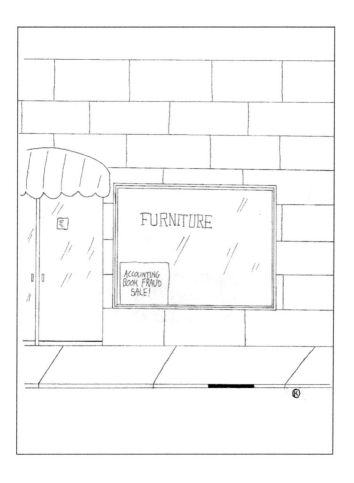

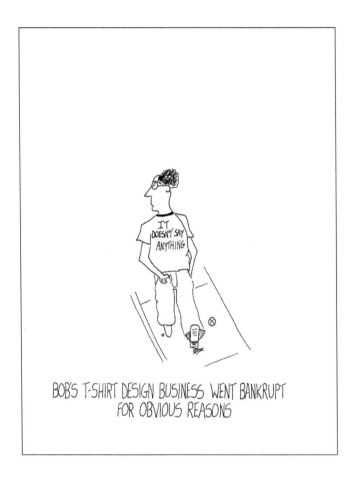

BOB'S T-SHIRT DESIGN BUSINESS WENT BANKRUPT
FOR OBVIOUS REASONS

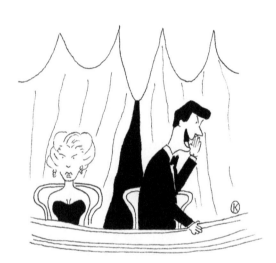

"HEY, FRANK! I'M IN THE CLASSY SECTION TONIGHT!"

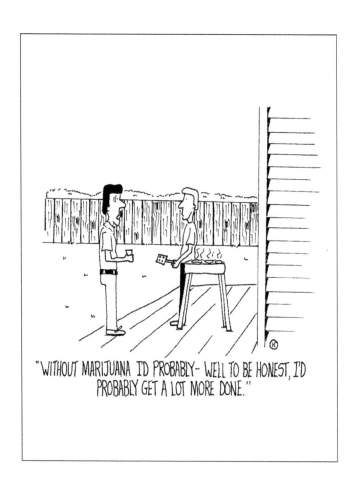

"WITHOUT MARIJUANA I'D PROBABLY– WELL TO BE HONEST, I'D PROBABLY GET A LOT MORE DONE."

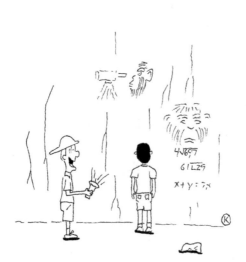

"DON'T YOU SEE WHAT THIS MEANS, JENKINS? ALL OF MANKIND DIDN'T EVOLVE FROM THE APES! ONLY THE SCIENTISTS DID!"

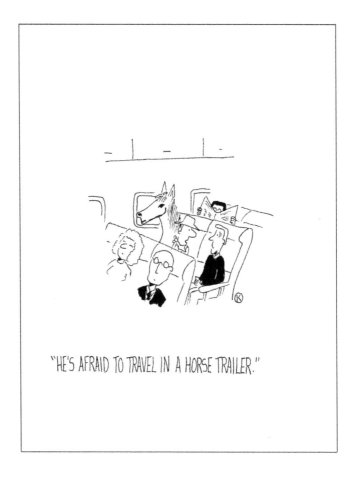

"HE'S AFRAID TO TRAVEL IN A HORSE TRAILER."

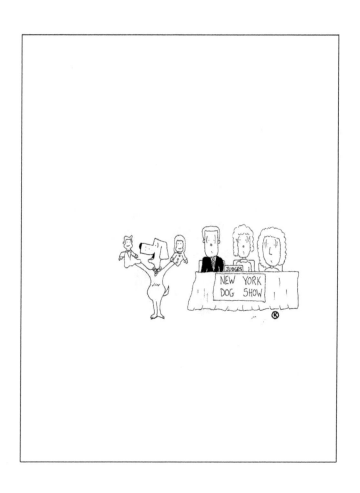

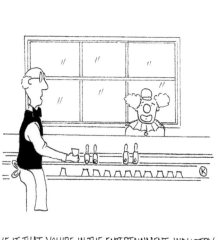

"I TAKE IT THAT YOU'RE IN THE ENTERTAINMENT INDUSTRY."

BILL'S ANCESTRY REPORT STATING HE WAS 50 PERCENT IRISH
WASN'T A SURPRISE, BUT THAT HE WAS ALSO 14 PERCENT ALUMINUM
HE FOUND A LITTLE TROUBLING.

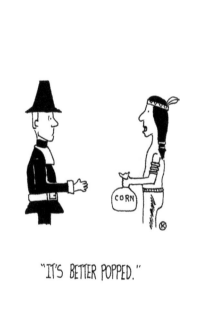

"IT'S BETTER POPPED."

"—AND IN WEATHER, HURRICANE THOR HAS BEEN
DOWNGRADED TO SUNSHINE."

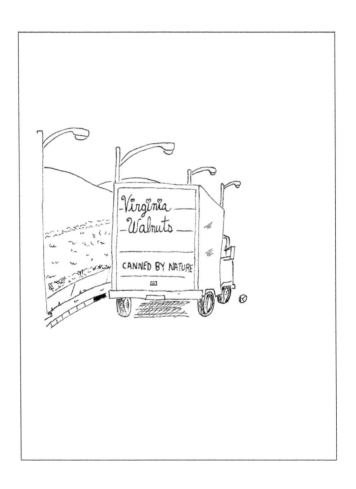

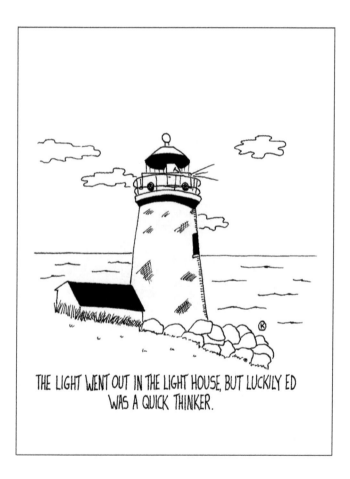

THE LIGHT WENT OUT IN THE LIGHT HOUSE, BUT LUCKILY ED
WAS A QUICK THINKER.

PERCY WILKINS WON A NOBEL PRIZE FOR DISCOVERING THE RHETORICAL TRIANGLE WHICH OF COURSE NEEDED NO EXPLANATION.

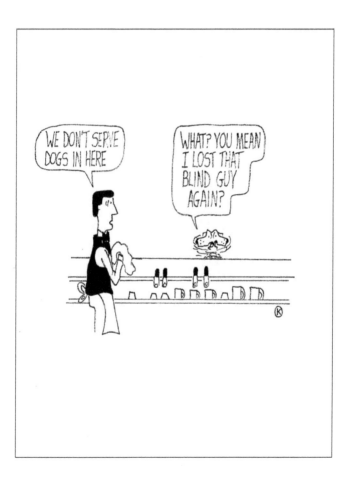

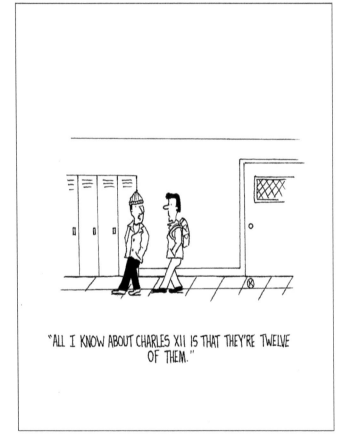

"ALL I KNOW ABOUT CHARLES XII IS THAT THEY'RE TWELVE OF THEM."

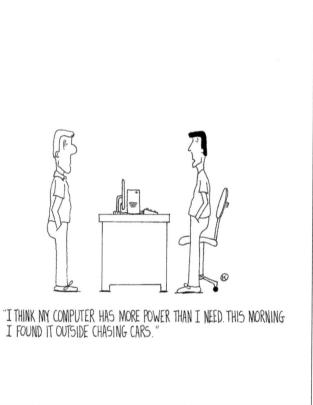

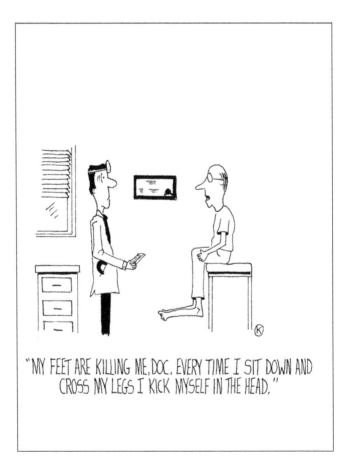

"MY FEET ARE KILLING ME, DOC. EVERY TIME I SIT DOWN AND CROSS MY LEGS I KICK MYSELF IN THE HEAD."

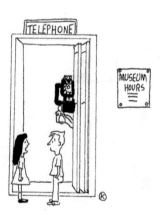

"HOW DID THEY CARRY IT AROUND WITH THEM?"

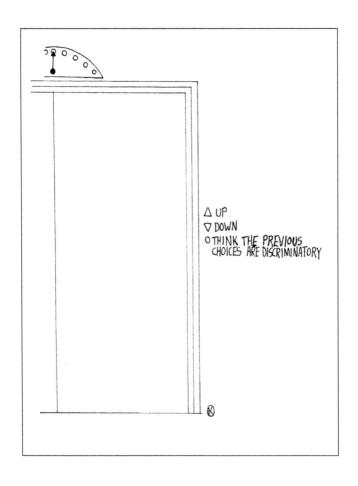

△ UP
▽ DOWN
○ THINK THE PREVIOUS
 CHOICES ARE DISCRIMINATORY

115

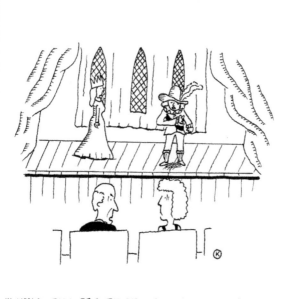

"WHEN DO THEY GET TO THE PART ABOUT KILLING ALL THE LAWYERS?"

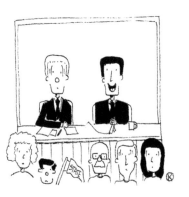

"ELVIRA STATE HAS WON THE COIN TOSS AND HAS ELECTED TO LEAVE."

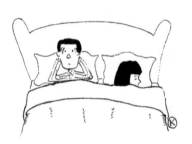

RICK HAD A WELL PAYING JOB, A GREAT FAMILY AND A HOUSE BY
THE LAKE, BUT HE KEPT THINKING THAT IF HE COULD ONLY WIN
THE NEW YORKER CAPTION CONTEST ONE TIME —

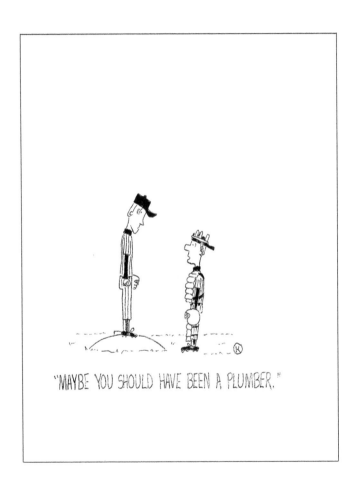

"MAYBE YOU SHOULD HAVE BEEN A PLUMBER."

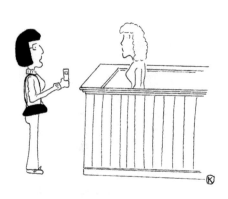

"I NEED TO EXCHANGE THIS BOOK "HOME REPAIR FOR DUMMIES" THAT I GOT MY HUSBAND FOR "HOME REPAIR FOR IDIOTS"."

"HE'S HAD ALL OF HIS SHOTS SO HE'S FULLY EUTHANIZED."

"ED HAD TO CLOSE HIS RESTAURANT DUE TO THE FACT THAT HE
COULDN'T GET ANY INSURANCE BECAUSE THE WIND KEPT BLOWING
IT OVER."

"I THINK YOU'RE OLD ENOUGH TO UNDERSTAND NOW—I GOT
YOU AT AN ANIMAL SHELTER."

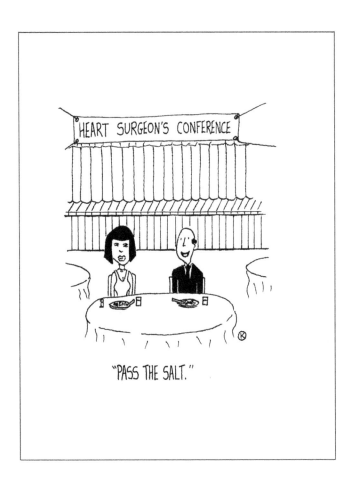

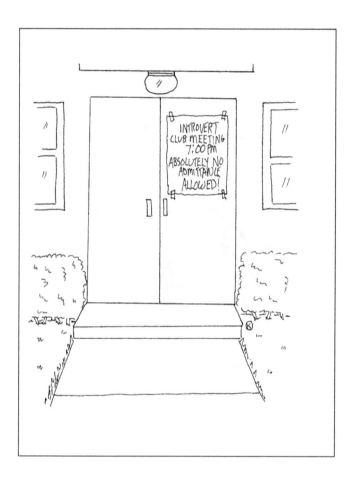

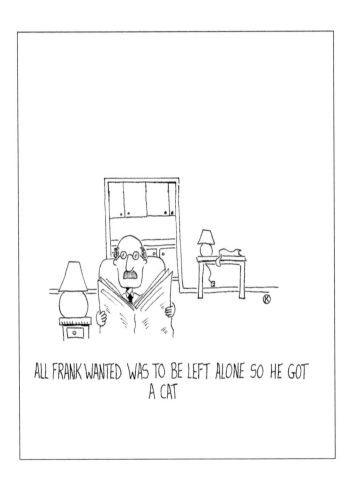

ALL FRANK WANTED WAS TO BE LEFT ALONE SO HE GOT
A CAT

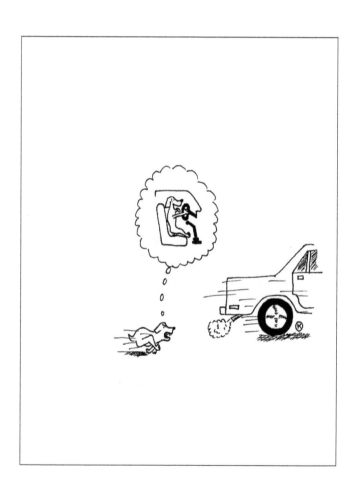

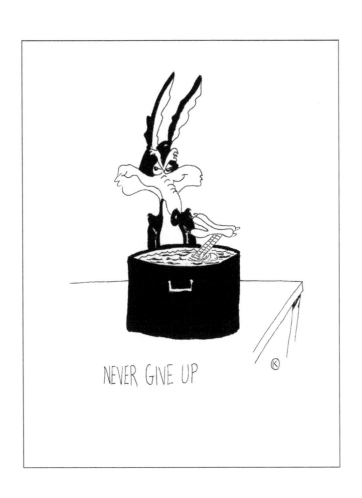

NEVER GIVE UP

About the Author

Kyle Owens lives in the Appalachian Mountains. His short stories have appeared in Liguorian, Binge Watching Cure Horror Anthology (October 2019), Alban Lake Publishing, among others. His romantic comedy novel, "A Mountain Christmas Wedding," will be published in October 2019 by Books to Go Now. His suspense thriller script has been adapted into the screenplay, "Eden Heights," and has the actress Julienne Davis ("Eyes Wide Shut") attached to the project and she is pitching it around Hollywood now. He can be reached at kyleowensprojects@hotmail.com

ALSO BY CLASH BOOKS

THE MUMMY OF CANAAN

Maxwell Bauman

TRAGEDY QUEENS: STORIES INSPIRED BY LANA DEL REY & SYLVIA PLATH

Edited by Leza Cantoral

GIRL LIKE A BOMB

Autumn Christian

THIS BOOK IS BROUGHT TO YOU BY MY STUDENT LOANS

Megan J. Kaleita

THIS IS A HORROR BOOK

Charles Austin Muir

FOGHORN LEGHORN

Big Bruiser Dope Boy

TRY NOT TO THINK BAD THOUGHTS

Art by Matthew Revert

SEQUELLAND

Jay Slayton-Joslin

JAH HILLS

Unathi Slasha

SPORTSCENTER POEMS

Poetry by Christoph Paul & Art by Jim Agpalza

DARK MOONS RISING IN A STARLESS NIGHT

Mame Bougouma Diene

GODDAMN KILLING MACHINES

David Agranoff

NOHO GLOAMING & THE CURIOUS CODA OF ANTHONY SANTOS

Daniel Knauf (Creator of HBO's Carnivàle)

IF YOU DIED TOMORROW I WOULD EAT YOUR CORPSE

Wrath James White

THE ANACHIST KOSHER COOKBOOK

Maxwell Bauman

HORROR FILM POEMS

Poetry by Christoph Paul & Art by Joel Amat Güell

NIGHTMARES IN ECSTASY

Brendan Vidito